Yellow Roses

Many beginners assume that roses are 'too difficult' and avoid these lovely flowers. However, the technique for painting them is just the same as in anything else in watercolour, so it is well worth having a go at roses.

The blue shading used here is almost transparent on the edge of the petals, so you must use a very thin wash. The warmer golds in the centres will be painted using a thicker wash.

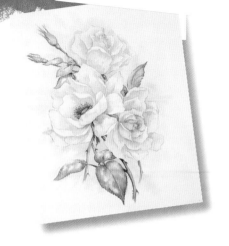

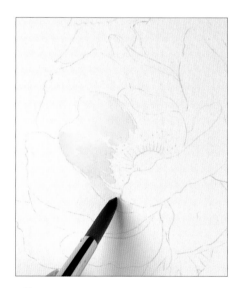

1 Transfer the image to paper and secure it to the board with masking tape. Use a size 10 brush to wet a petal of the central rose, then drop in a mix of cadmium lemon and quinacridone gold. Draw the paint towards the centre, leaving plenty of paper showing through for highlights.

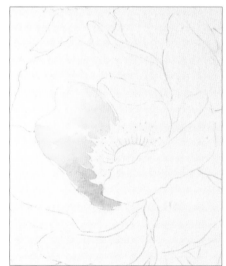

2 Add a little extra quinacridone gold to the mix as you reach the bottom of the petal for shading. Adding extra quinacridone gold warms the colour.

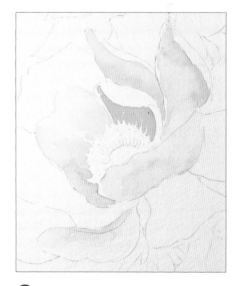

3 Paint the other inner petals of the rose in the same way, working wet-in-wet. Note that the closer the petal is to the centre of the flower, the warmer the colour.

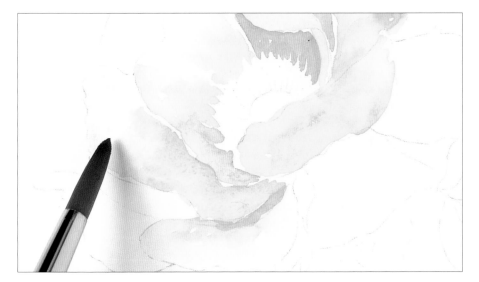

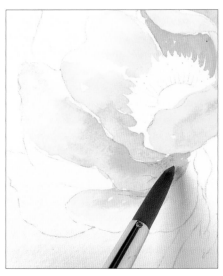

4 Move on to the outer petals, using a mix with more cadmium lemon. Drop the paint in the centre of the petals and draw it towards the centre of the flower. Working wet-in-wet, add a thin wash of cobalt blue to the outside edges of the petals, allowing it to bleed into the yellow.

5 Once the flower is dry, clean the brush, dry it, and add a touch of quinacridone gold wet-on-dry in the deepest recesses of the flower near the centre. Soften the edge with water.

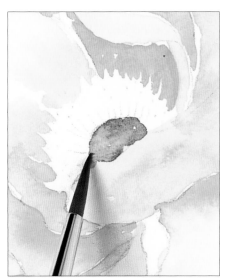

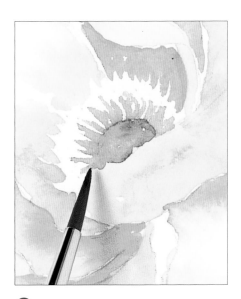

6 Paint the rest of the outer petals in the same way, with warmer mixes (i.e. more quinacridone gold in the mix) on the inside and for shading, and cooler mixes (more cadmium lemon) on the outside and for highlights. Use a touch of thin cobalt blue for the edges of the petals as before.

7 Make a thin mix of brown madder and paint in the rose's centre. Draw a clean damp brush across the middle of the area to lift out a little of the paint and create a highlight.

8 Draw the paint out while wet to form stamens. For finer control, draw your brush lightly over a cloth rag to draw off excess paint and water.

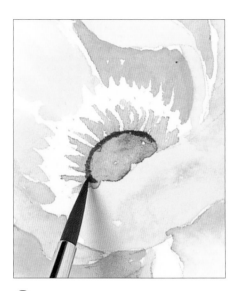

9 Make a stronger mix of brown madder with cobalt violet, and draw a fine line around the centre of the rose.

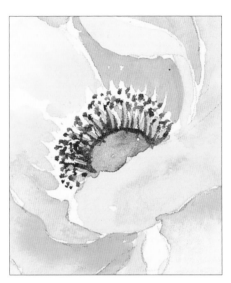

10 Draw the paint out to form darker stamens, then stipple the tips by dotting paint on to the very ends of the paint strokes.

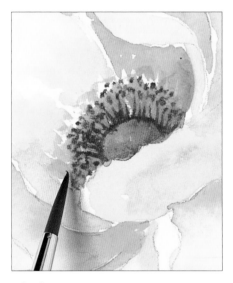

11 Allow to dry thoroughly, then glaze the centre with a thin wash of quinacridone gold and cadmium orange to complete the central rose.

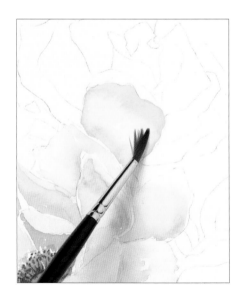

12 Make a stronger mix of cadmium lemon and quinacridone gold and draw a wide, wet outline round one of the petals of the flower above the completed rose.

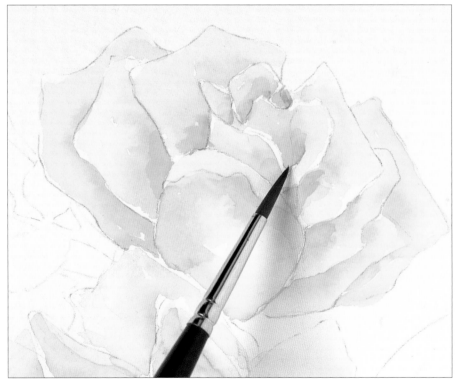

13 Paint the other petals of the uppermost flower, adding a touch more quinacridone gold on the central petals. At the very centre, add a touch of cadmium orange.

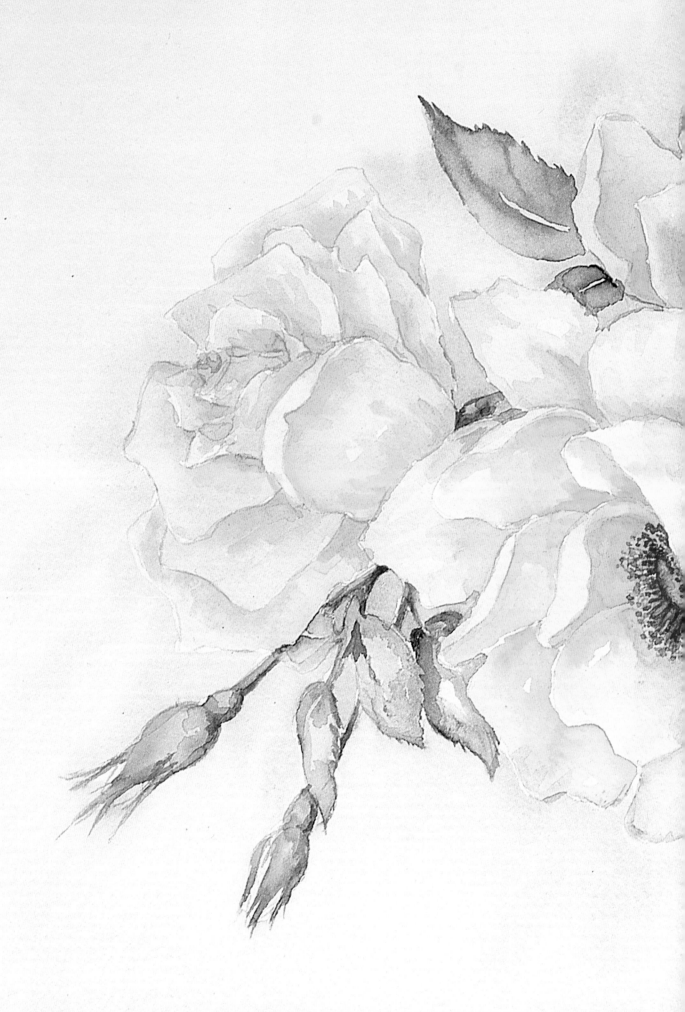

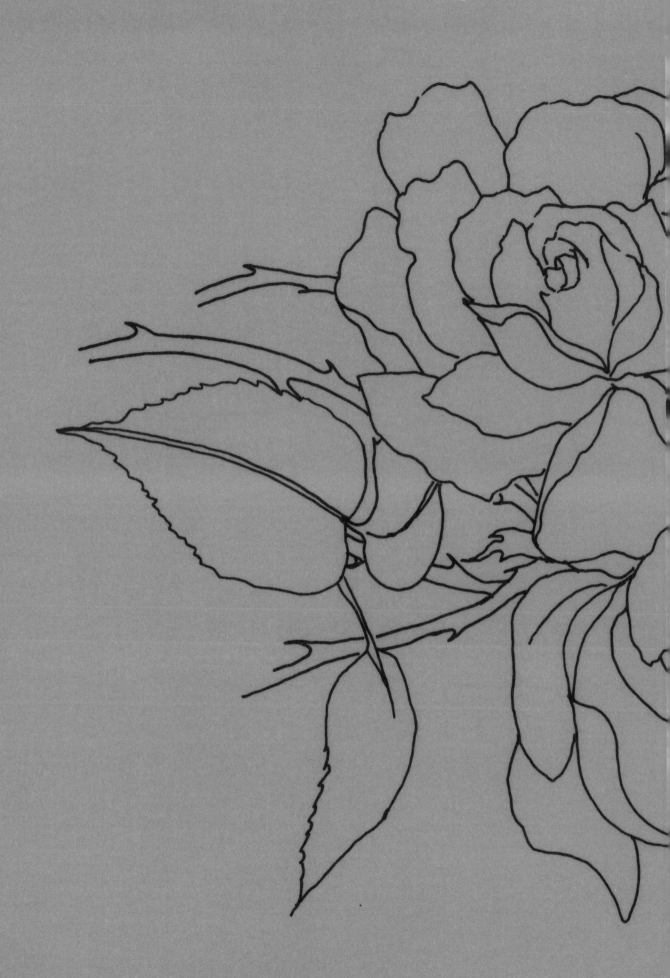

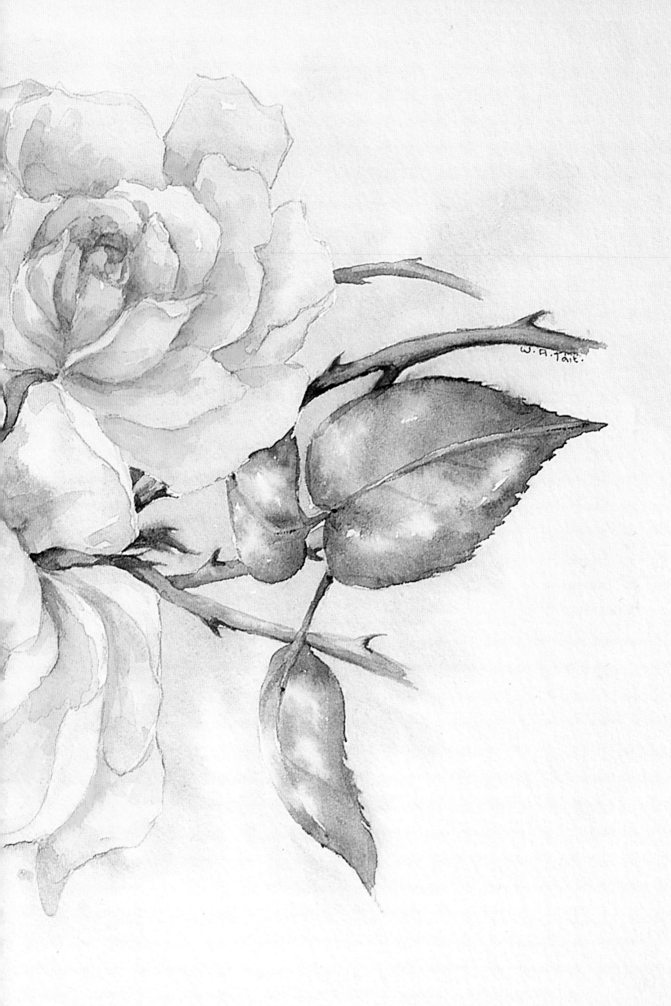

14 Paint the flower at the bottom of the picture. This flower is warmer-toned, so use more gold in the basic mix, and add a touch of permanent rose for the shading.

Tip
Watercolour paints will appear lighter when they are dry than when they are wet, so bear this in mind as you paint the shades.

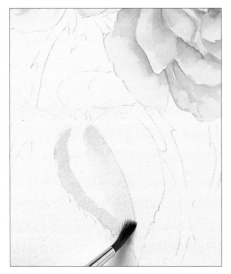

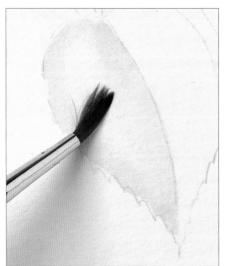

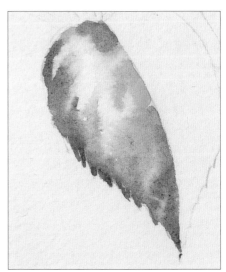

15 Make a thin mix of cobalt blue and use the size 4 brush to paint a thick outline round the left-hand segment of the large leaf at the bottom of the painting. Lay the brush almost flat to prevent a hard line from forming, and make sure that the paint is very dilute.

16 While the outline is still wet, drop clean water into the centre of the leaf and encourage the blue outline to blend into the water, leaving a light centre to the leaf.

17 Make a mix of cadmium lemon and quinacridone gold with a touch of indigo. Drop it in wet-in-wet as the blue paint starts to dry. Add a touch of indigo for shading at the edges.

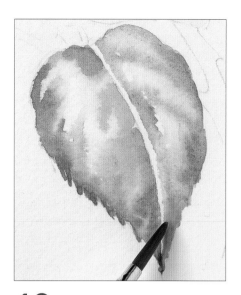

18 Paint the other half of the leaf in the same way, leaving a thin white border between the two.

19 Paint the remaining leaves with the same technique, paying attention to which parts of the leaves are in the shade.

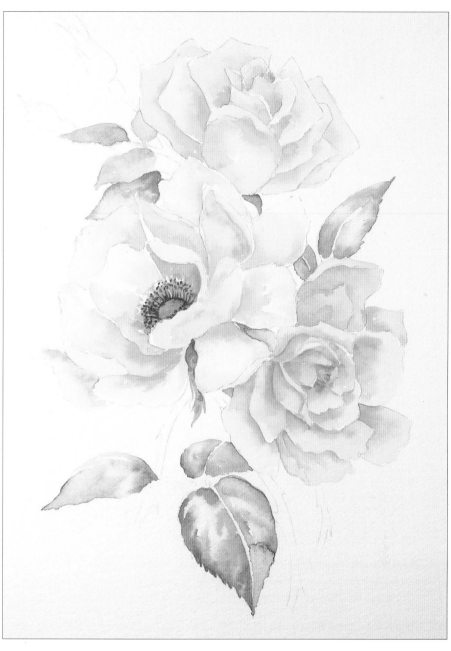

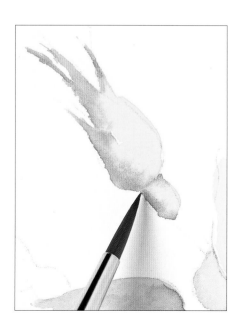

20 Add more cadmium lemon to the green mix and paint in the buds at the top of the painting, adding permanent rose wet-in-wet for the side in shadow. Finally, add fine detail to the bud with the dark green mix used on the leaves.

21 Pull the dark shade down the stem and then, without washing your brush, pick up some permanent rose and restate the whole stem. Soften the transition between the shading and main colour with a little water.

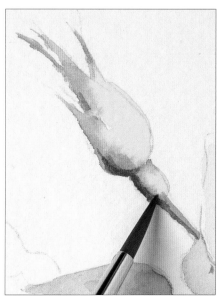

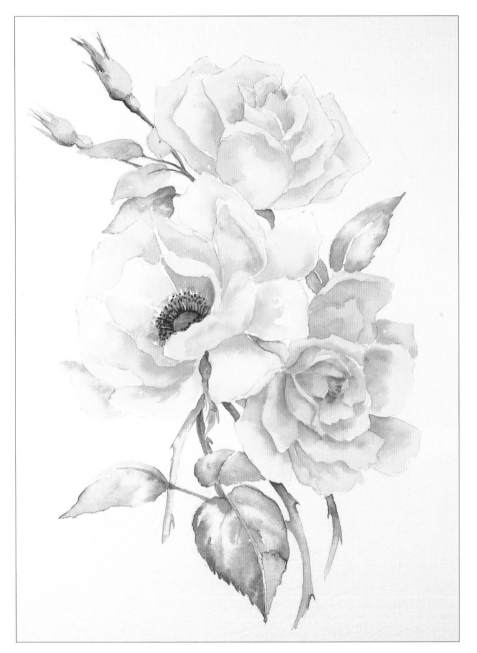

22 Paint the other bud in the same way, then use the red and green mixes to paint the stems and thorns at the bottom. Deepen the red with brown madder for shading. This red mix can also be used for the veins of leaves.

Tip

Where the stem is green, shade it with dark red. Where the stem is red, shade it with dark green.

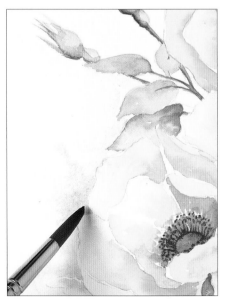

23 Wet the paper on the left-hand side right to the edge of the paper, then drop in a cobalt blue wash a finger's width from the painting and draw the wash towards the flowers.

24 If the paper is still wet, continue adding a faint blue backdrop around the flower. If it is dry or merely damp, allow it to dry completely, then re-wet it and continue until the background is completed. Where the background is completely enclosed by the picture, you can paint the blue wet-on-dry.

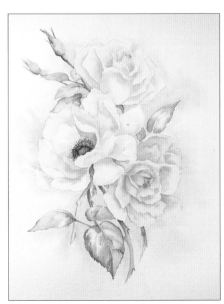